Shuichi Tsunoda is a Tokyo-based commercial photographer
and Azuki's owner. In 2016, Shuichi started an Instagram account for
Azuki, which quickly gained hundreds of thousands of followers.
Shuichi was born in Tokyo in 1975. Having graduated from the
Department of Graphic Design at Tama Art University,
he started working as a freelance photographer in 1998.

http://shuichitsunoda.com/

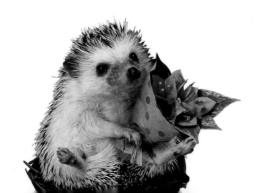

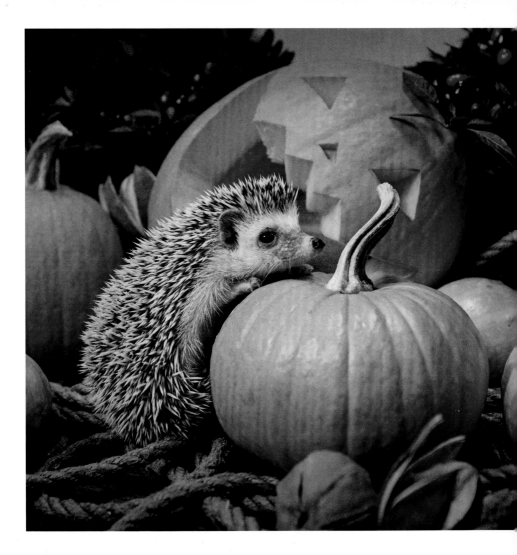

THE
ADVENTURES
OF
AZUKI
THE
MINIATURE
HEDGEHOG
AND FRIENDS

SHUICHI
TSUNODA

ROBINSON

ROBINSON

First published in Great Britain in 2019 by Robinson

A CIP catalogue record for this book is available from the British Library.

ISBN: 978-1-47214-299-3

Designed by Andrew Barron/Thextension
Printed and bound in China by C&C Offset Printing Co., Ltd.

Papers used by Robinson are from well-managed forests
and other responsible sources

Robinson
An imprint of
Little, Brown Book Group
Carmelite House
50 Victoria Embankment
London EC4Y 0DZ

An Hachette UK Company
www.hachette.co.uk

www.littlebrown.co.uk

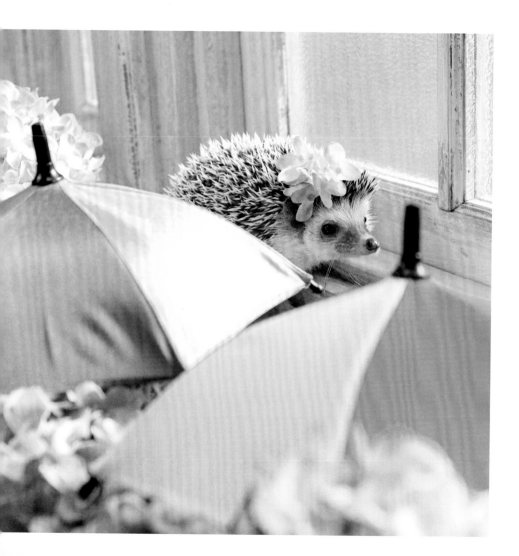

INTRODUCTION

In 2016, Tokyo-based photographer Shuichi Tsunoda started an
Instagram account for his miniature hedgehog, Azuki, and a star
was born! Today, Azuki and his daughter Monaka's Instagram
account has over 400,000 followers.

Azuki was born on 15th January 2016, and his daughter,
Monaka, was born on the 8th April 2018. 'Azuki' means 'red bean' or
'red bean paste', while Monaka's name is taken from a type of
Japanese sweet made using azuki beans.

This collection of adorable photographs of Azuki shows him,
Monaka and other family members and friends playing pool,
cooking, reading and enjoying other mini-adventures.
The full list of family and friends is given opposite.

A HEDGEHOG WHO'S WHO...

AZUKI'S FAMILY
Azuki @hedgehog_azuki♂
Monaka @hedgehog_azuki ♀ – Azuki's daughter
Uni @uni_desu ♀ – Azuki's girlfriend
Toro @uni_desu ♀ – Azuki's daughter
Ao @ao20180408 ♂ – Azuki's son

AZUKI'S FRIENDS
Matthew @darcytheflyinghedgehog ♂
Ocean @radotink_hedgehog ♂
Sky @tomtom1486 ♂
Ichigo @ichigo_chiyoco ♂
Silva @ichigo_chiyoco ♂

PRICKLY GARDEN, HIDING HEDGEHOGS!
STEP FORWARD, THE REAL AZUKI!
(OR I'M COMING TO GET YOU WITH MY LITTLE SHOVEL.)

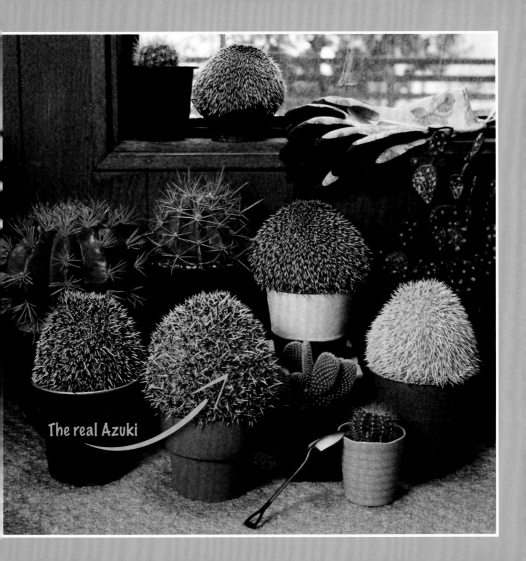

The real Azuki

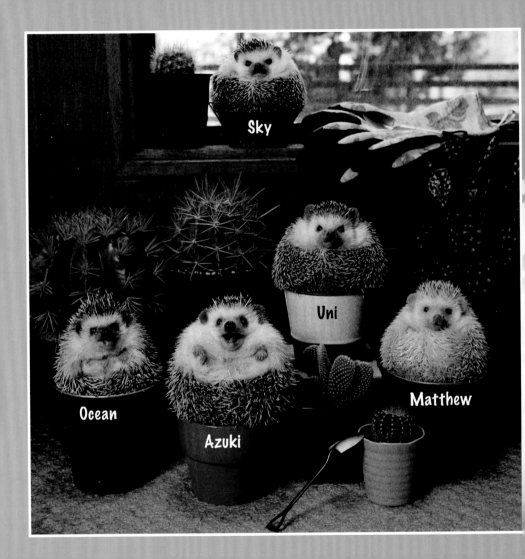

IT'S A HEDGEHOG HARVEST!

POOL PARTY!

BEWARE THE HEDGEHOG HUSTLERS.
AZUKI, WITH THE CUE, HANGING WITH HIS HEDGEHOG FRIENDS.

'Clear the baize,
Uni and Sky!'

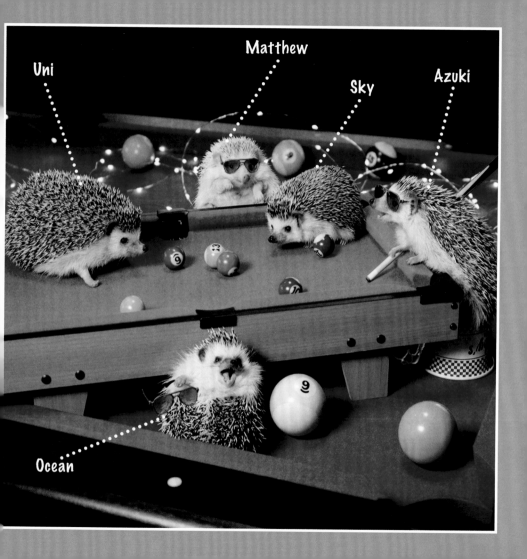

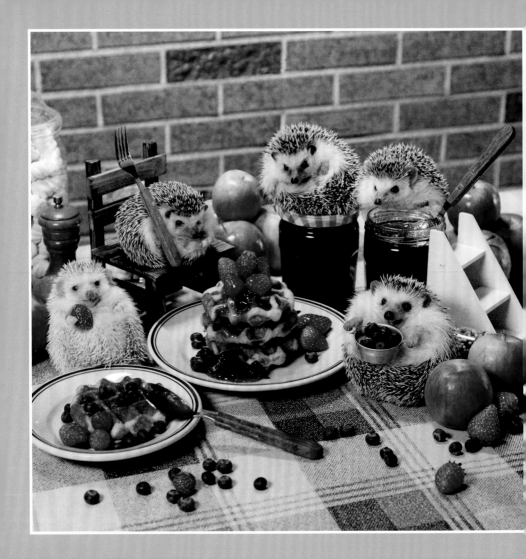

IT'S WAFFLE TIME!

A PRICKLY PARTY WITH (CLOCKWISE FROM THE LEFT):
MATTHEW, SKY, OCEAN, UNI AND AZUKI,
ABOUT TO TUCK INTO A LITTLE BOWL OF BLUEBERRIES.

I love strawberries!

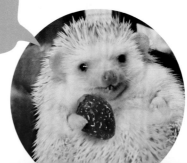

'It's the popcorn
that goes in the tubs,
Ocean and Sky!
Not you two clowns!'

'SORRY.'

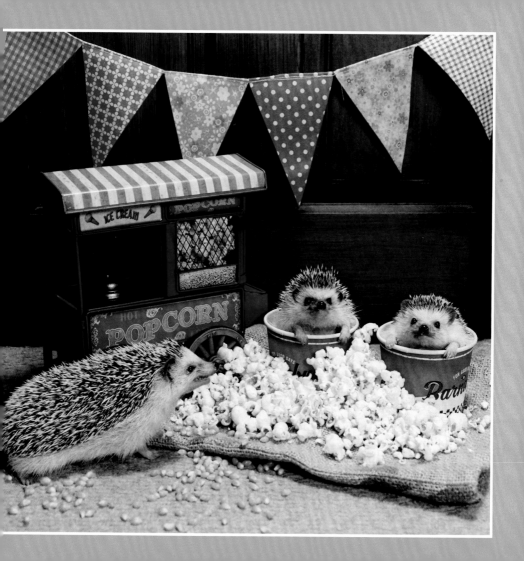

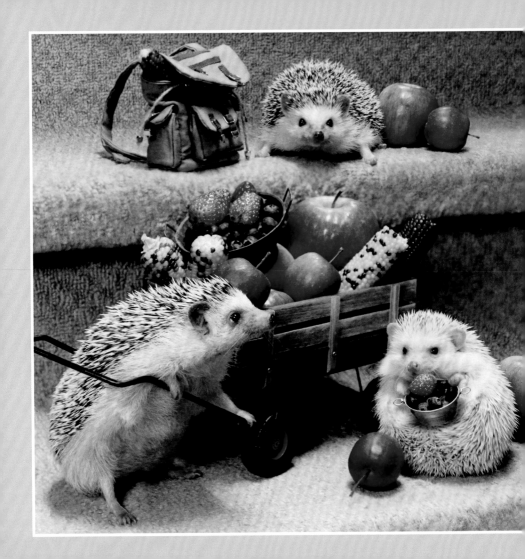

'Get the festival truck out.
We're going camping!'

'IT'S A
FRUITFEST!'

'Do we have
enough apples?'

'Everyone say "CHEESE!". Sit up straight, Matthew!'

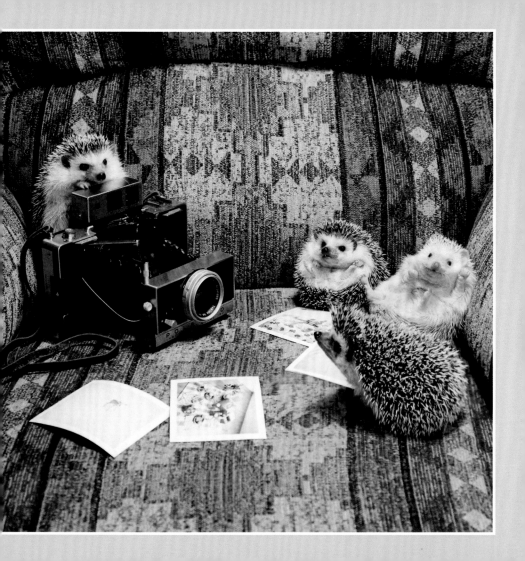

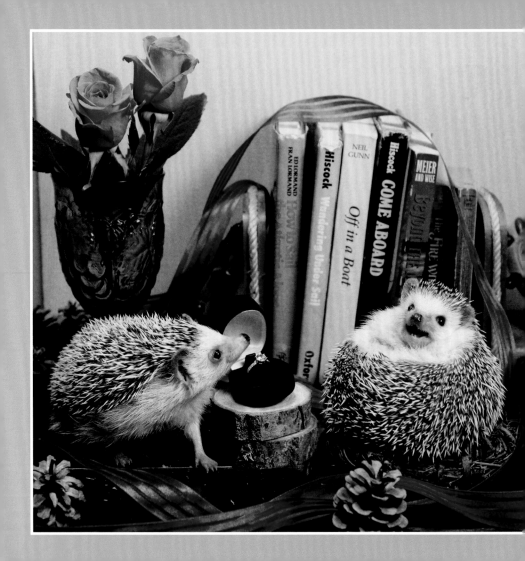

'MARRY ME, UNI!'

'That's quite some ring, Azuki!'

'But I wanted
blueberries, Dad,
not cherries!'

'Come down, Monaka.
Don't be scared.
I'll hold the ladder.'

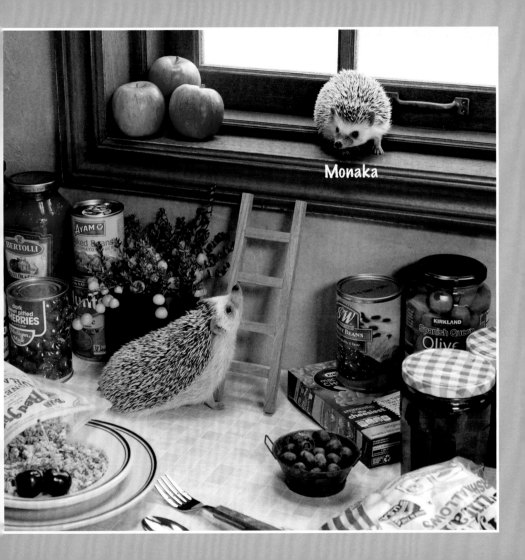
Monaka

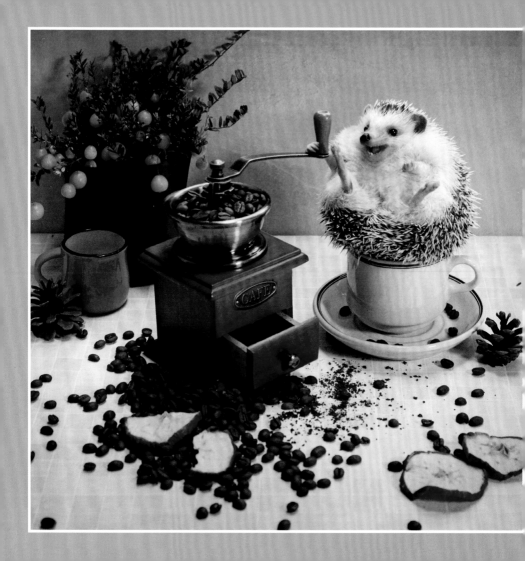

'I'm not really cut out to be a barista.'

AZUKI LOVED THE SMELL OF FRESHLY GROUND COFFEE, BUT HE DIDN'T LIKE TO DRINK IT!

'It's party time!'

'Bunting? Check.
Party shoes? Check.'

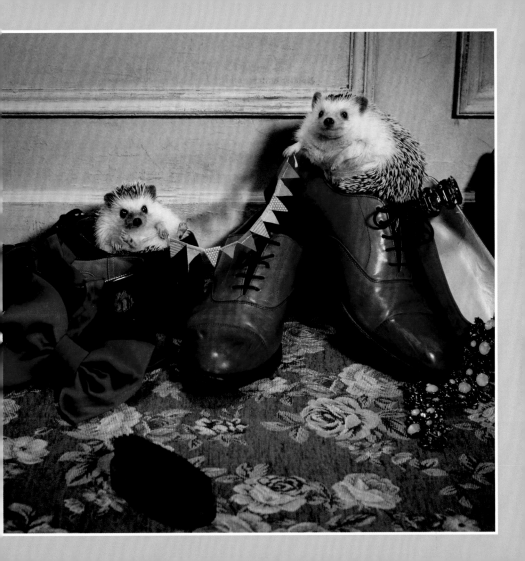

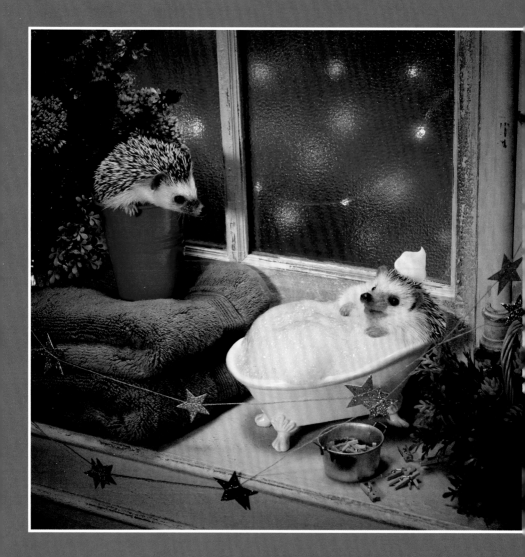

FLUFFY TOWELS AND TINY PEGS.

AZUKI LOVES TO RELAX IN A NICE BUBBLE BATH.

(MONAKA PREFERS A SMALL FIRE BUCKET.)

'What on earth...?
It's a butterfly barrage!'

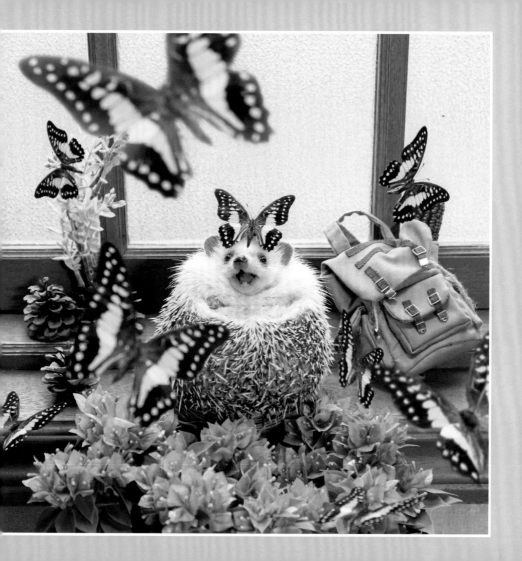

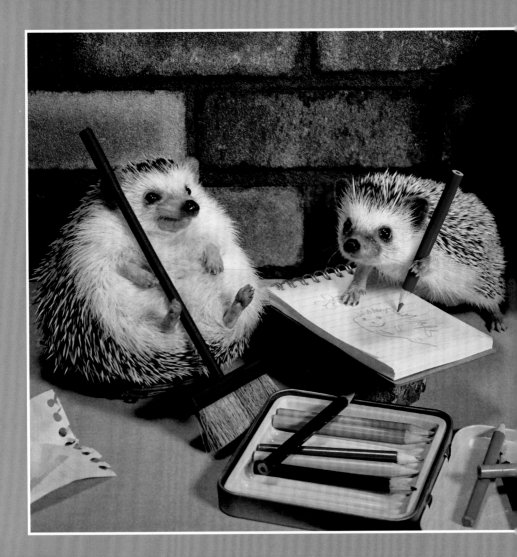

'I'm drawing you, Dad!'

'Good likeness, Monaka! Did you get the broom?'

'The housework is never done, Toro!'

'Get out of that bin, my girl, and lend a hand!'

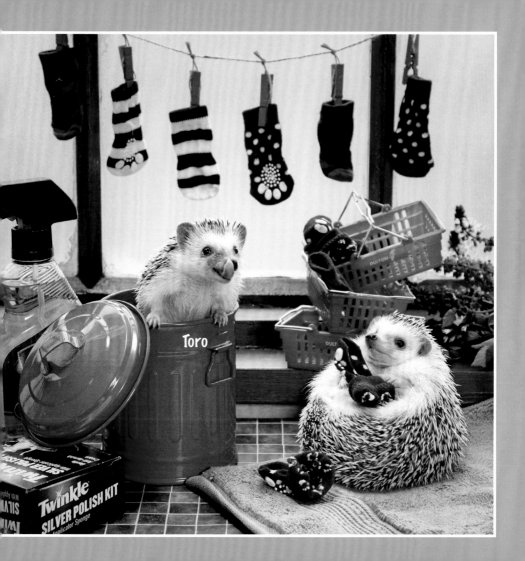

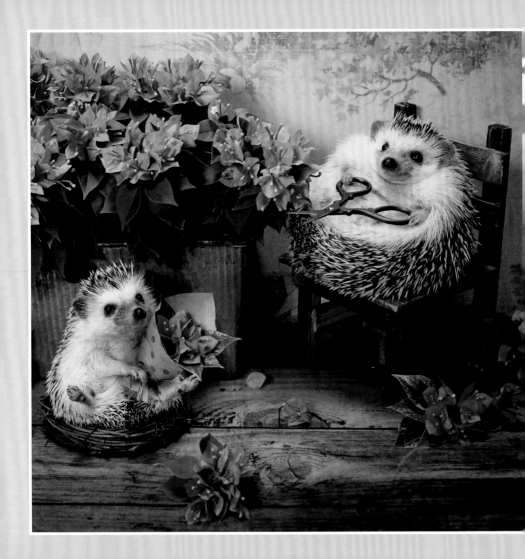

'We love corn on the cob!'

'Perhaps too much!'

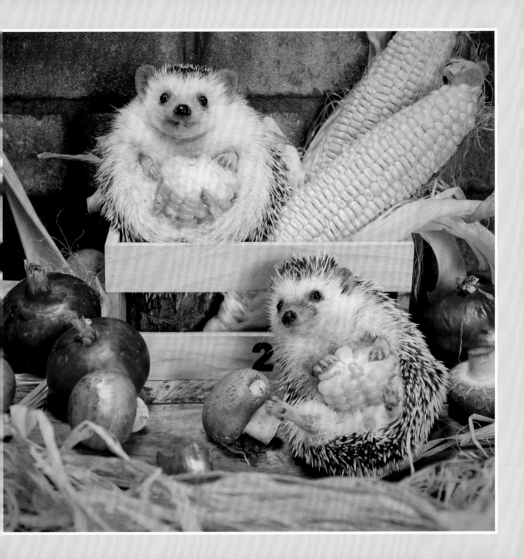

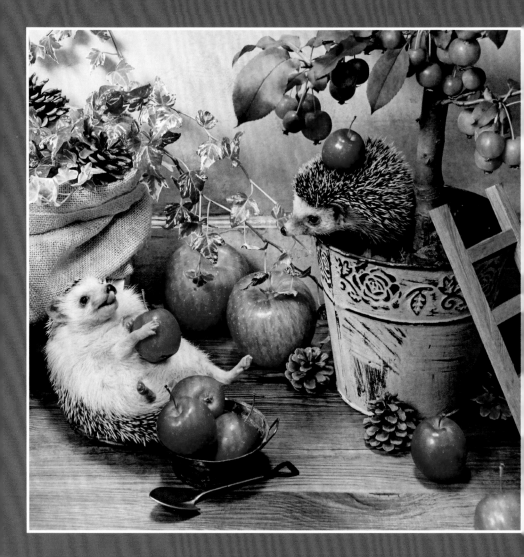

'It's raining apples!'

'Is it? I can't feel a thing!'

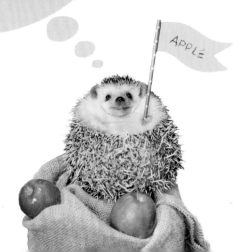

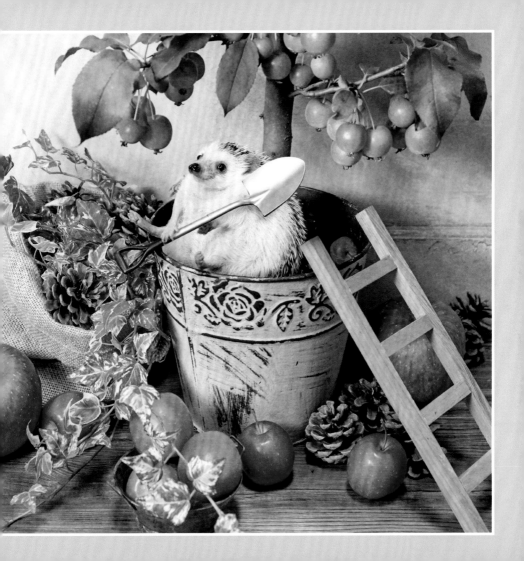

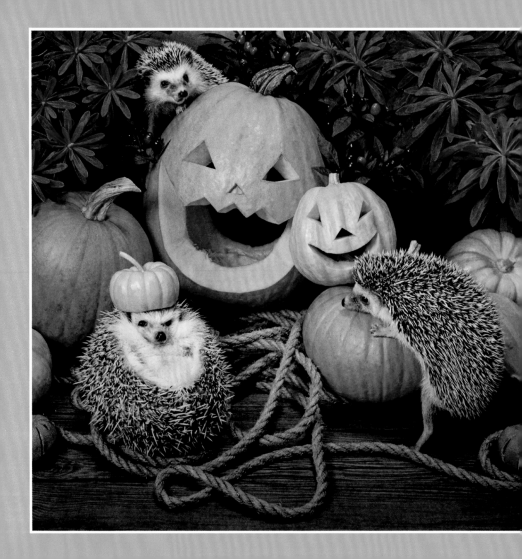

'Spooky hat, Azuki!

'I love Halloween . . . or do I just love pumpkin?'

'OOF!
Help me out of here, guys!'

'A bowl of
pumpkin seeds!
My Halloween is
complete!'

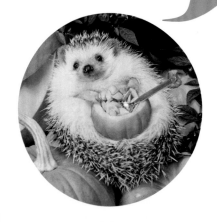

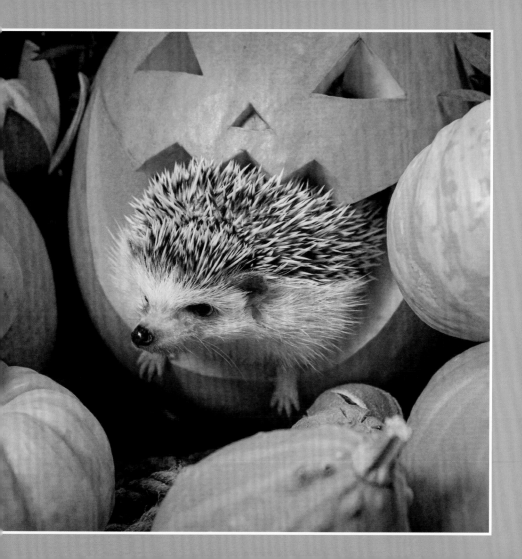

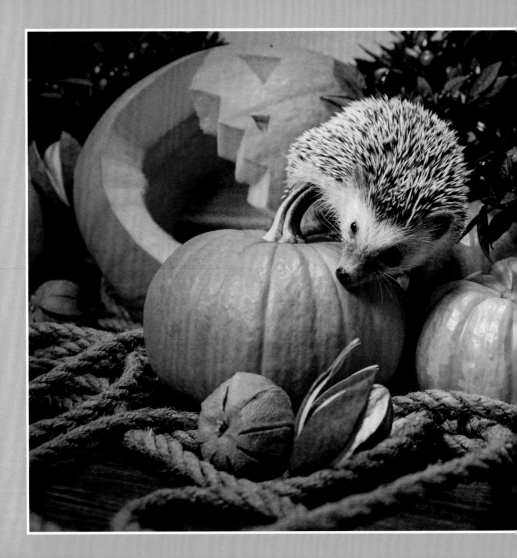

‘I knew it!
Dried orange.
A hedgehog's nose
never lies!’

‘Steady, Toro.
Don't slip now.’

'Quietly does it.
Hold on tight, hedgehogs.
Don't fall, anyone!
Down we go…'

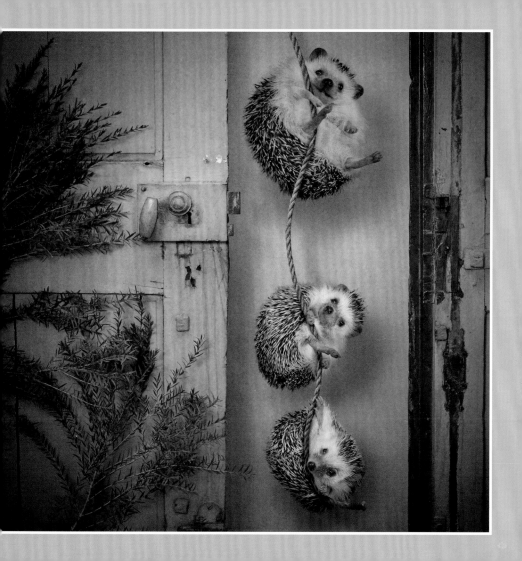

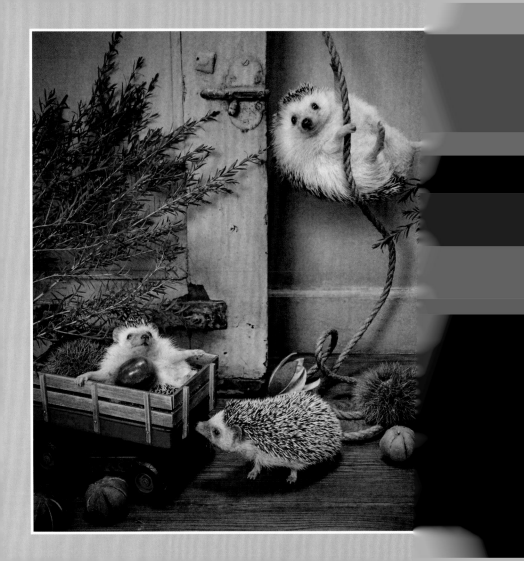

'You made it.
Wait for me. Don't let me
fall on you!'

'I love fresh pasta!'

'But it's hard work for a small hedgehog!'

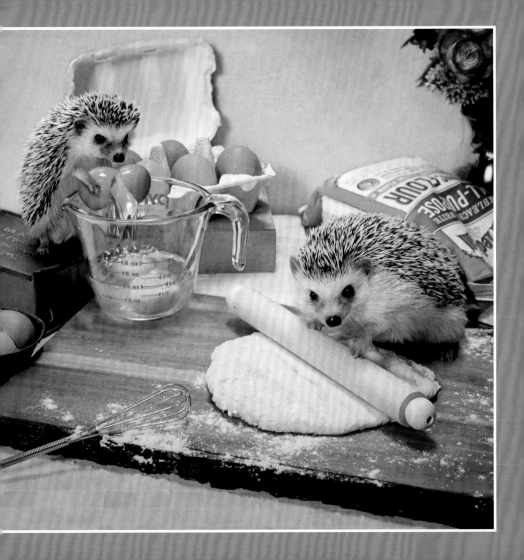

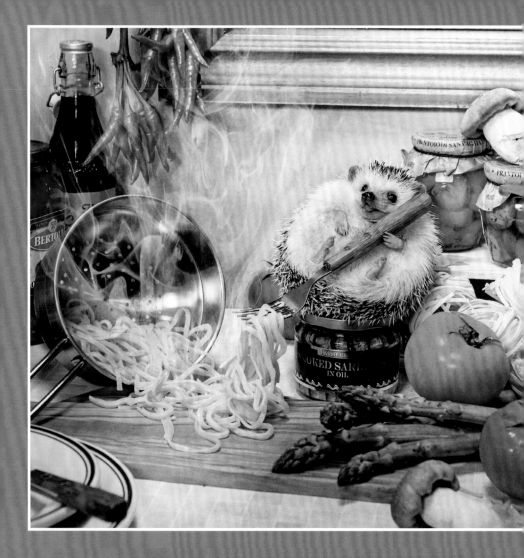

'This pasta is HOT!'

'Nice pappardelle bows, girls!'

'Come on, let's eat!'

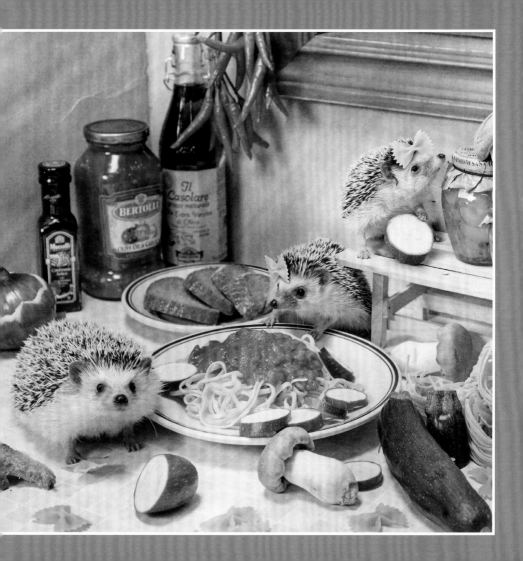

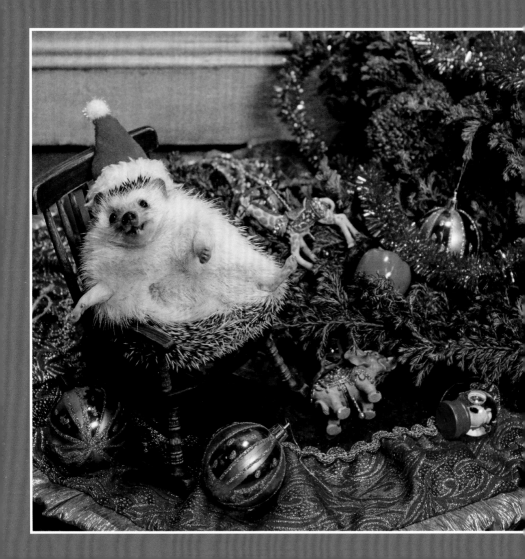

'When I was young, Christmas was my favourite time of the year.'

'You're not so old *now*, Dad! Come on, help me open my present.'

'Go on, Monaka, help yourself to an apple pie. I've already got one!'

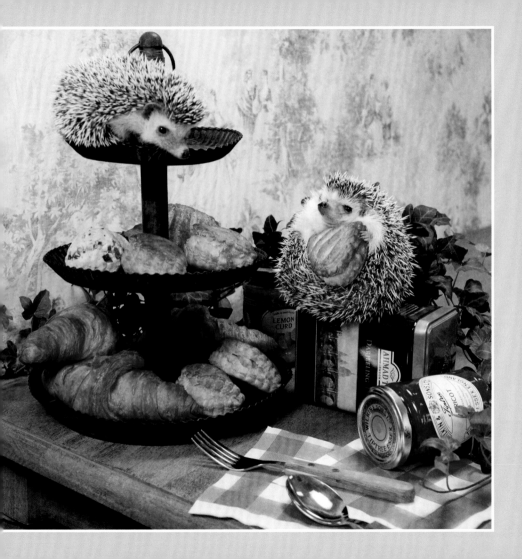

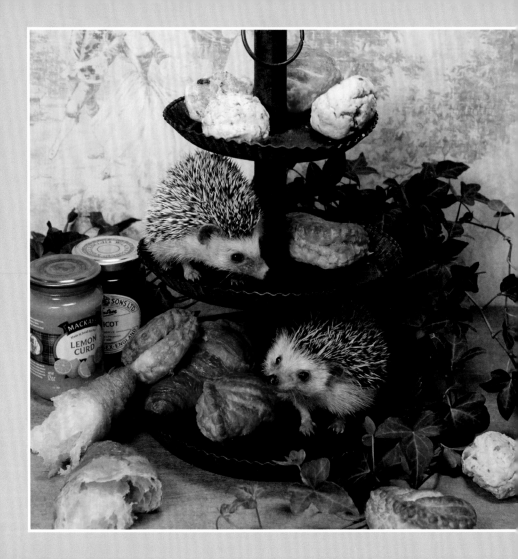

'Come on up,
Dad. There's one
more up here.'

'There are
plenty down here,
Monaka!'

'Now that's what
I call an apple pie!
It's so WIDE!'

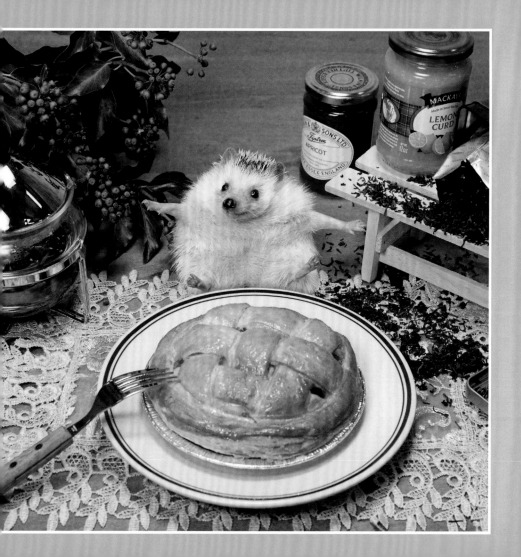

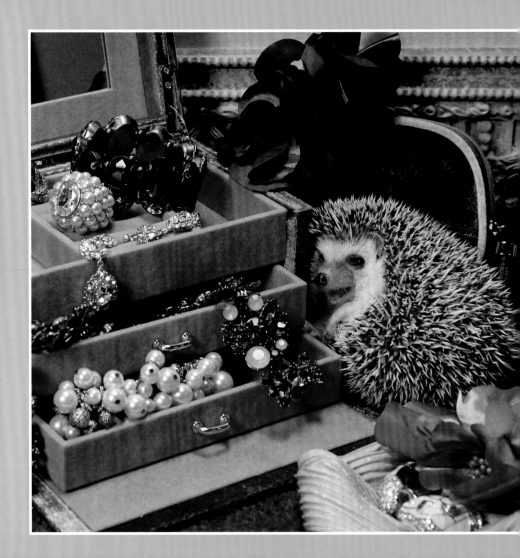

'I love to dress up.
These are some of my
favourite jewels!'

'This is not just thrown together. When I accessorise, I do it right!'

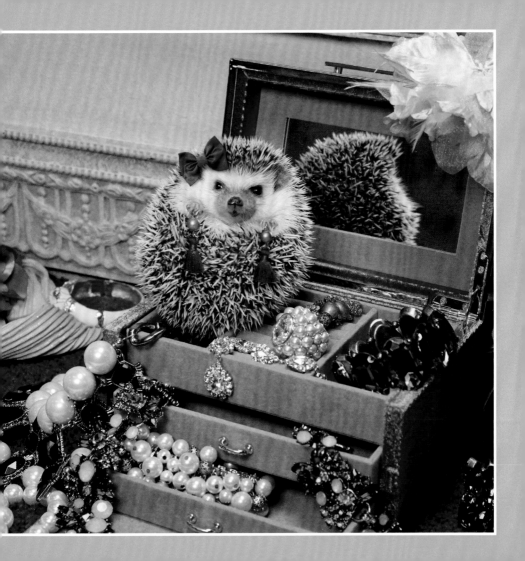

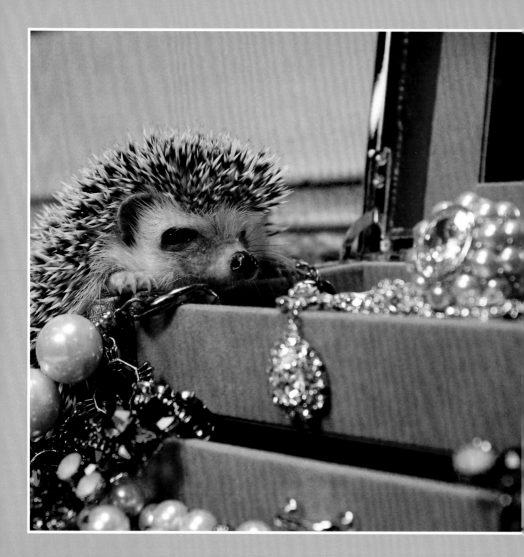

'No, that wasn't quite right... something else, perhaps...'

'What a beautiful piece! That large DIAMOND. Yes, that's the one.'

AZUKI LOVES READING.

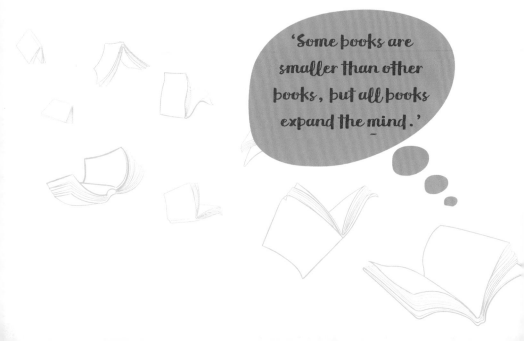

'Some books are smaller than other books, but all books expand the mind.'

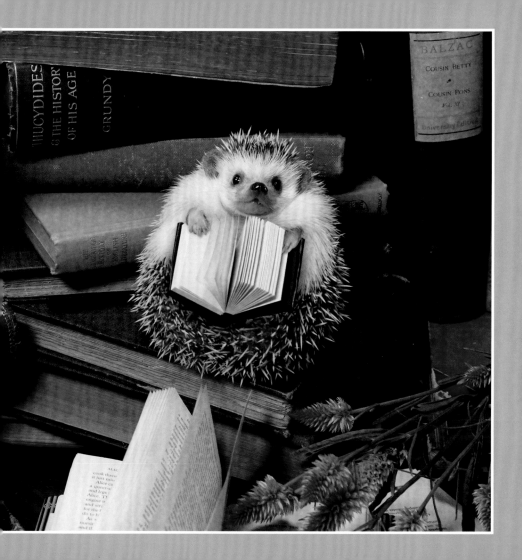

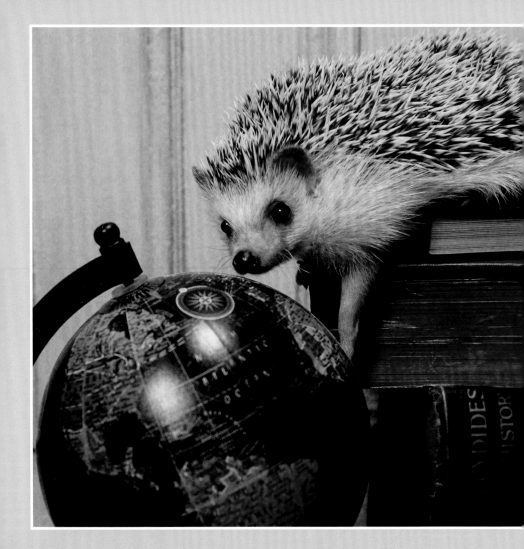

'Through books,
one can travel
anywhere in the world.
I would like to go
to Europe.'

'Grundy?
That is not a name
that I'm familiar
with.'

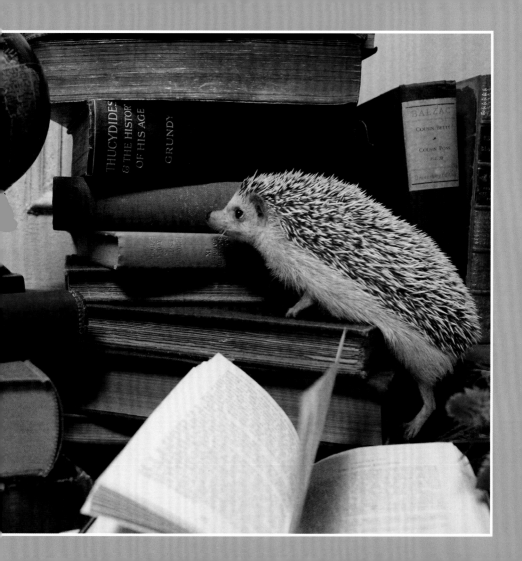

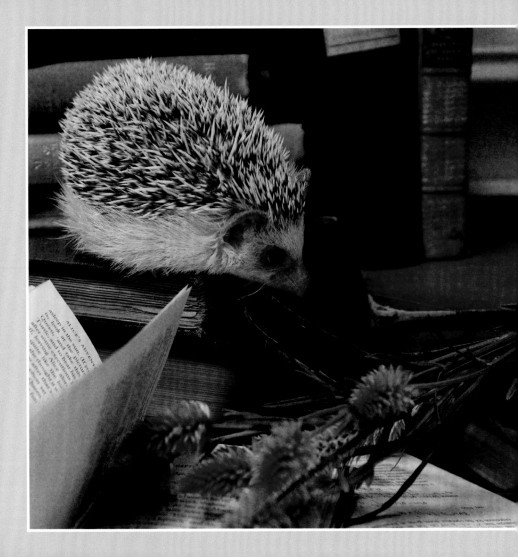

'Books are the flowers of the greatest minds who have ever lived.'

'I've always felt that this writer is overrated . . .'

'Now this is interesting!'

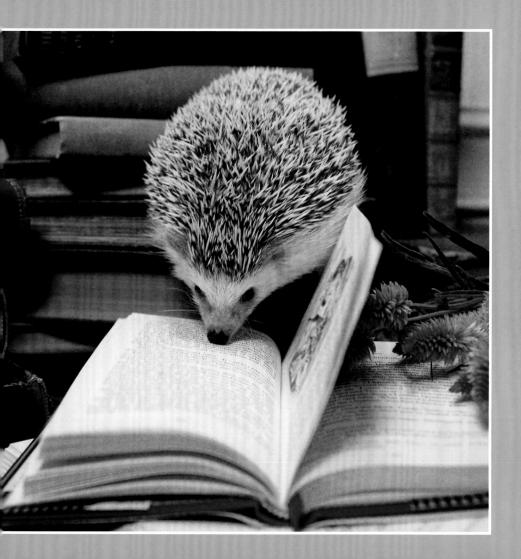

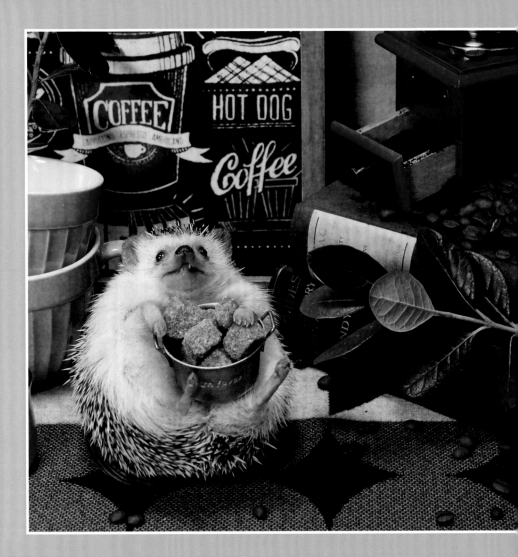

'Sugar.
It's bad for me, but I can't
live without it.'

'Just one cube
can't hurt me . . .
It calls to me.'

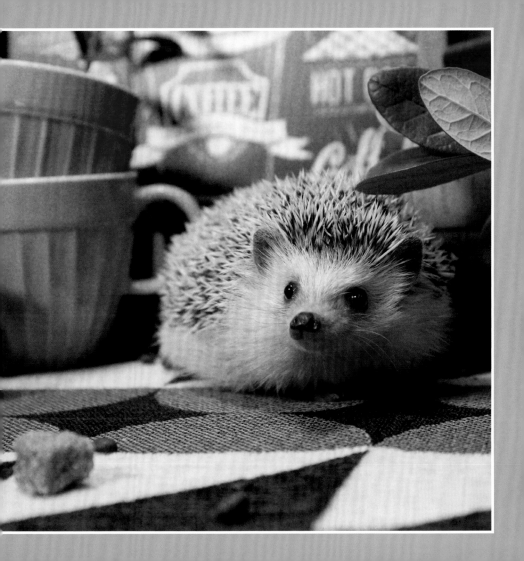

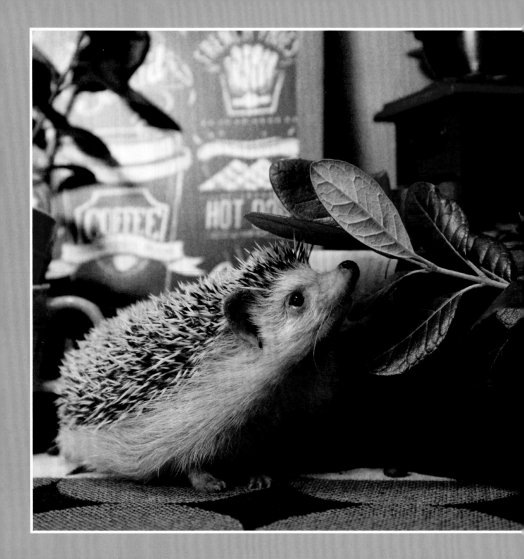

'Perhaps this
leaf may distract
me from my
cravings . . .'

'NO.
It's just not
working . . .'

'Get me out of these cups! I need SUGAR!'

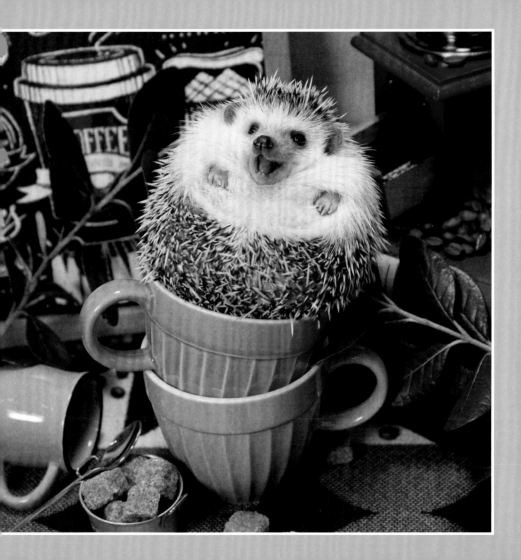

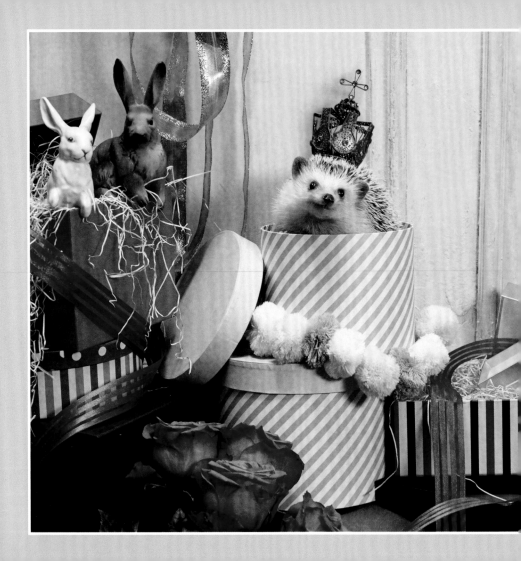

'A hedgehog and two hares in a box . . . what's going on here?'

'Are they real?
I suspect not.'

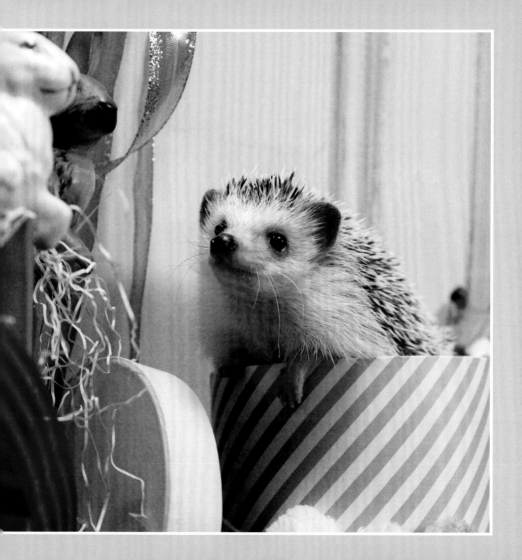

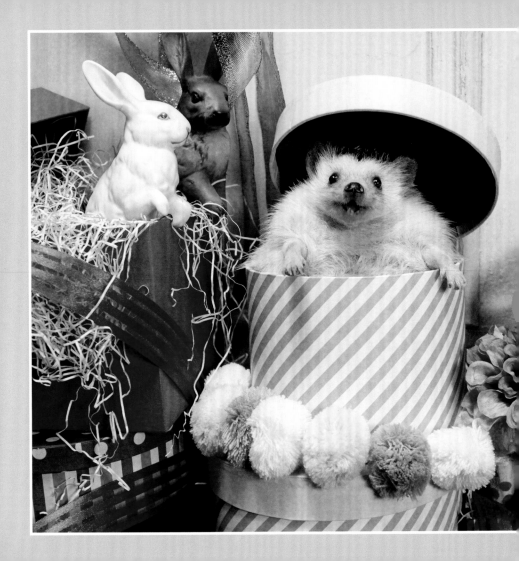

'THEY'RE NOT.
That's a shame.
I could have used
some company.
I may simply
pop the lid on
my box and have
a little nap.'

'I like a bit of caramel sauce on my cheesecake, I cannot tell a lie. Let's hope I don't puncture the plastic bottle.'

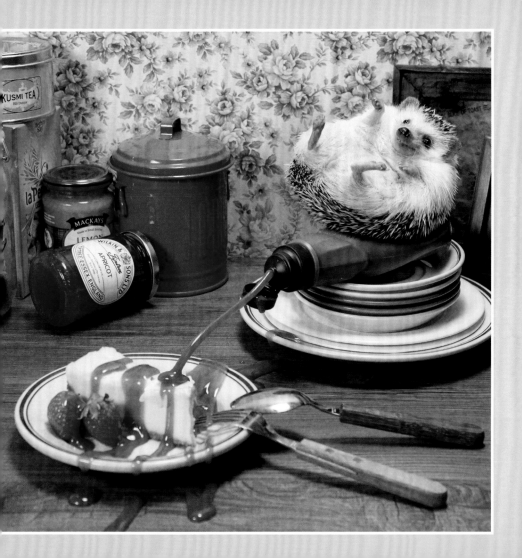

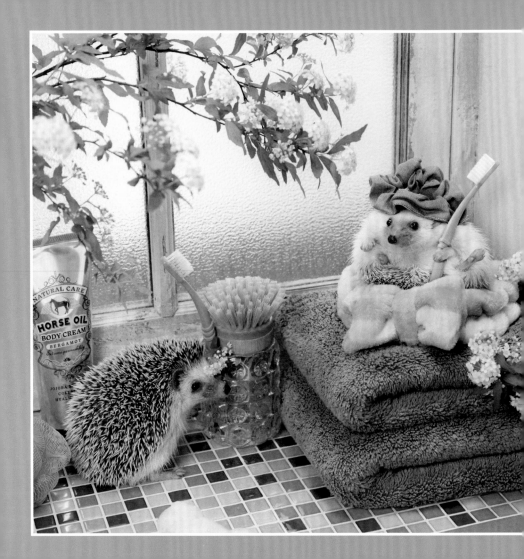

'Personal hygiene is paramount, especially brushing one's teeth.'

'We are also great fans of HORSE OIL body cream. Perhaps that surprises you?'

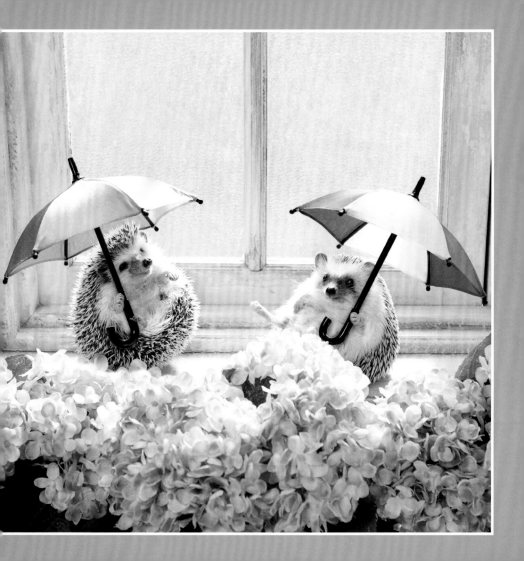

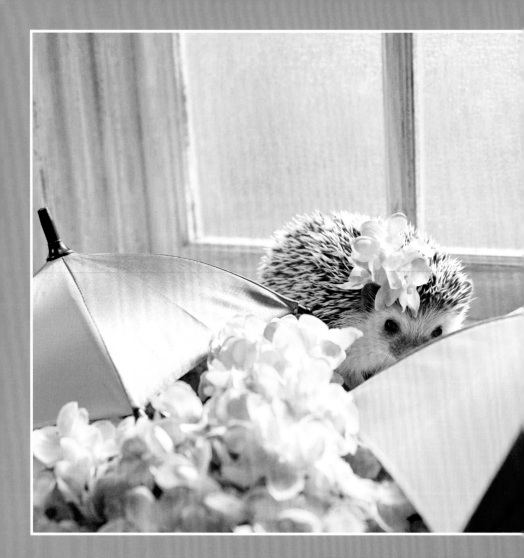

'You're right.
There is no rain.
It is a day for wearing
flowers on my head
instead.'

'How curious! These
flowers have no scent.'

'HELP,
I'm being attacked by a sloth!'

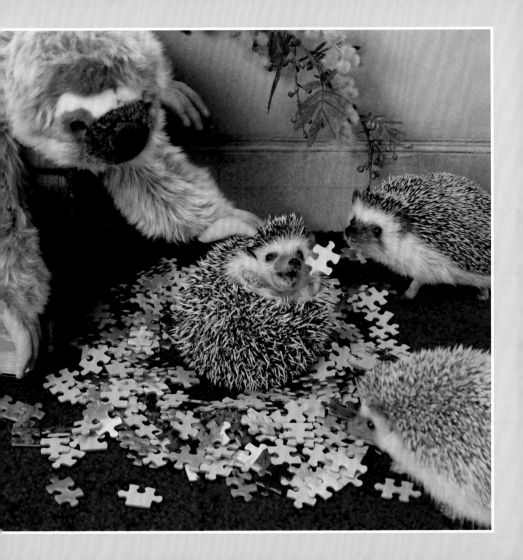

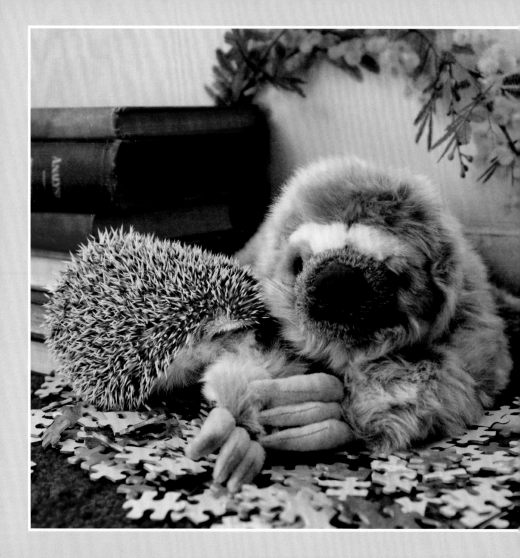

'Hang on, I know sloths are slow, but this is ... ah, I see, he's not real.'

'Well, are you real ... or not?'

'You can still be my friend and help me with this jigsaw puzzle. Come on!'

'No, I thought not. I feel a bit sad.'

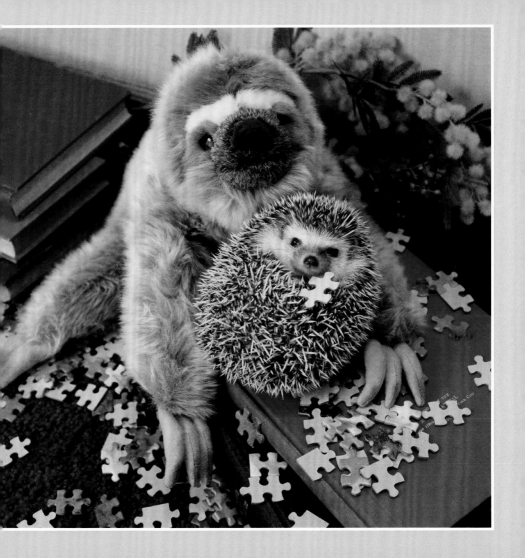

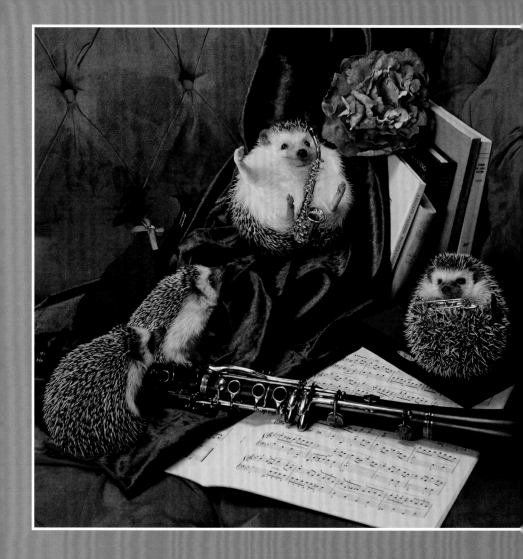

'We should form
a band!'

'But your saxophone
and my tiny trumpet
are so much smaller
than that clarinet, Dad!'

'Even two of us would struggle to play this!'

'HANG ON, I think the mouthpiece is at the other end.'

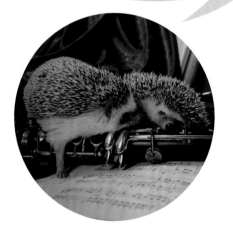

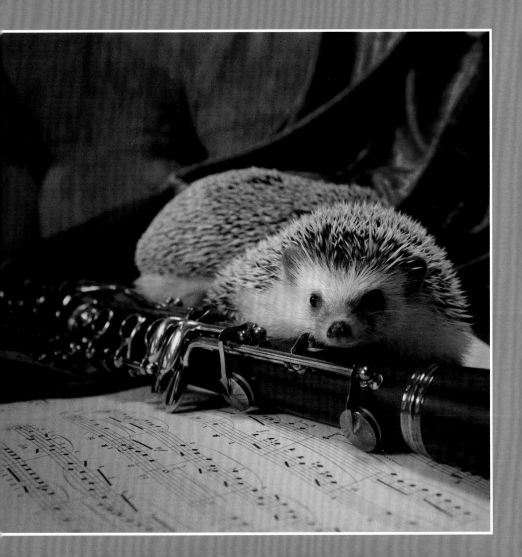

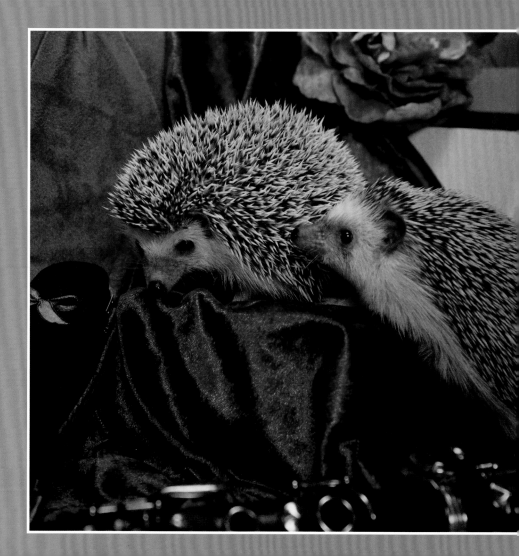

'Come on! Hurry up, Monaka, or we'll never get the hang of this.'

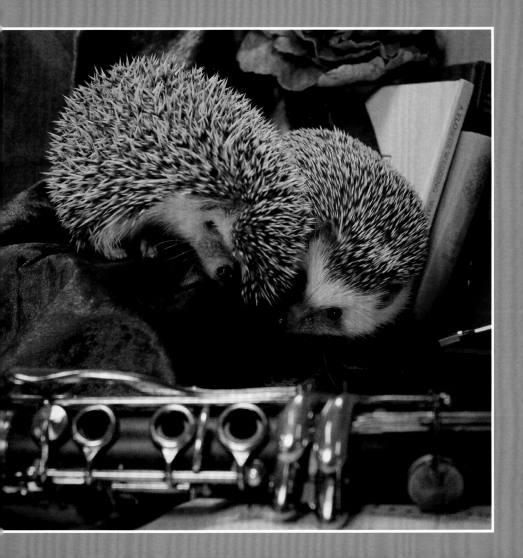

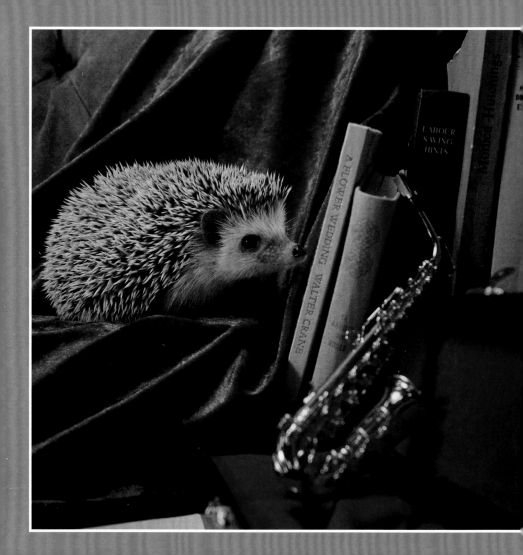

'…though hang on,
where's Dad gone?
He was on sax.'

'This looks more
like the right size …'

'It's going to be quite a squeeze, but I like this house! You're doing a GOOD job, Monaka!'

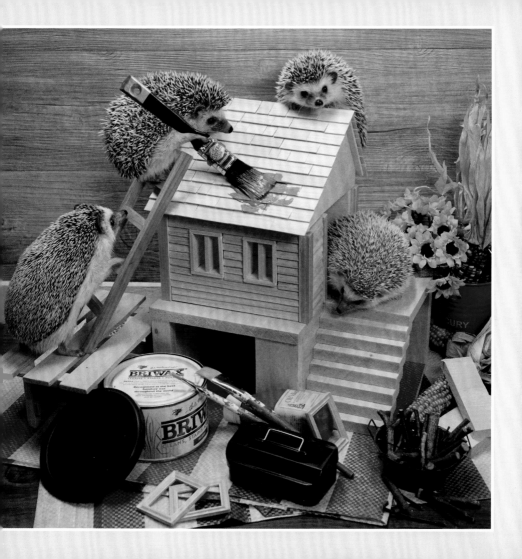

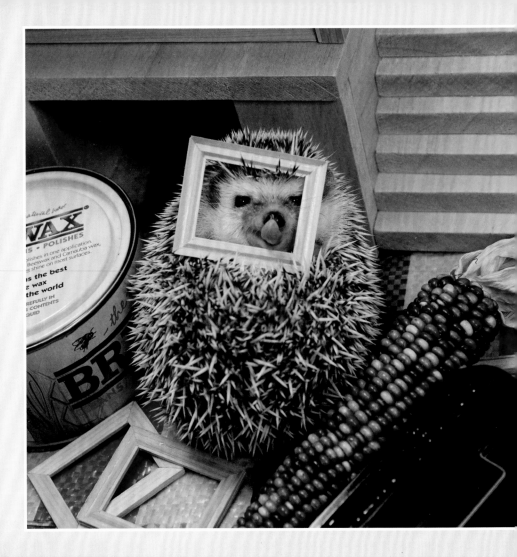

'I like the idea of some portraits, extreme close-ups, framed. Like this!'

'Or like this? More serious!'

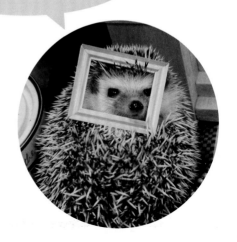